Malcolm and the Mechanics - Garage 3

Artist **Yve Slater** spent a summer working in a cafe connected
to a garage making (slightly dodgy) coffee for the mechanics.
This series explores the beauty that emerged out of the chaos
of their workshops.

The Cheltenham Illustration Awards have been running since 2008
as part of the Pittville Press at the University of Gloucestershire in
the beautiful Cotswold countryside. Every year, the Illustration awards
receives hundreds of entries and the organization showcases the best
of student and emerging illustrators from all over the world. The winners
of the Cheltenham Illustration Awards are featured in an annual printed
catalog and the winning artworks are displayed at an exhibition at the
London Book Fair each spring.

Artwork:
Malcolm and the Mechanics - Garage 3 © Yve Slatery
Graphite on multiple A3 papers

Published by teNeues Publishing Company
© teNeues Publishing Company
All rights reserved.

www.teneues.nyc